С О К Р О В И Щ А   Р О С С И И

# JEWELS OF THE ROMANOVS

*Treasures of The Russian Imperial Court*

PRESENTED BY THE

AMERICAN-RUSSIAN CULTURAL COOPERATION FOUNDATION

IN COOPERATION WITH

THE MINISTRY OF CULTURE OF THE RUSSIAN FEDERATION

AND

MUSEUM-EXHIBITION "DIAMOND FUND," GOKHRAN, RUSSIA

STATE ARCHIVES OF THE RUSSIAN FEDERATION

STATE MUSEUM-PRESERVE "TSARSKOYE SELO"

YAROSLAVL ARCHITECTURAL AND HISTORICAL MUSEUM-PRESERVE

STATE MUSEUM-PRESERVE "PAVLOVSK"

*Houston, Texas*
*Museum of Fine Arts*

**RUSSIAN ORGANIZING COMMITTEE:**
Vitaly N. Ignatenko, Chairman

**RUSSIAN LENDING INSTITUTIONS:**
State Archives of the Russian Federation
Director - Sergei Mironenko

Museum-Exhibition "Diamond Fund," Gokhran, Russia
Director - Victor Nikitin

Yaroslavl State Architectural and Historical Museum-Preserve
Director - Veniamin Lebedev

State Museum-Preserve "Tsarskoye Selo"
Director - Ivan Sautov

State Museum-Preserve "Pavlovsk"
Director - Yuri Mudrov

**RUSSIAN ART DIRECTOR:**
Vladimir Ustimenko

**RESEARCHERS:**

| | |
|---|---|
| *Diamond Fund* | Lili Kuznetsova |
| *Yaroslavl* | Nina Gryaznova |
| *Pavlovsk* | Alexei Guzanov, Natalia Vershinina, |
| *Tsarskoye Selo* | Larisa Bardovskaya, Georgi Vedenskii, |
| | Asya Kolesnikova |
| *Archives* | Olga Barkovets, Alexander Savelyev, |
| | Nina Stadnichuk, Eleonora Nesterova |

**RUSSIAN CURATORS:**
Galina Abramova, Larisa Bardovskaya, Olga Barkovets,
Nina Gryaznova, Alexei Guzanov

**THE CURATORS OF THE EXHIBITION WOULD LIKE TO THANK:**
Alexandra Alekseeva, Gennady Boyarinov, and Tatiana Dudakova

**U.S. HONORARY COMMITTEE:**
Hon. Gerald D. Ford and Maurice Tempelsman, Co-Chairmen

**AMERICAN-RUSSIAN CULTURAL COOPERATION FOUNDATION:**
Hon. James W. Symington, Chairman of the Board
H. E. Yuli M. Vorontsov, Ambassador of the Russian Federation,
 Honorary Director

Directors:
Dwayne O. Andreas
Hon. Howard H. Baker, Jr.
Hon. Esther L. Coopersmith
Marshall B. Coyne
Michael B. Goldstein, Esq.
Richard D. Jacobs
Donald M. Kendall
John Krimsky, Jr.
J. Willard Marriott, Jr.
Robert M. McGee
Mikhail N. Novikov
Rabbi Arthur Schneier
Shelley M. Zeiger

Alexander P. Potemkin, Executive Director
Corinne M. Antley, General Counsel
Arnold P. Lutzker, Special Counsel

**U.S. CURATORS AND COORDINATORS:**
Susan Peacock, Exhibition Coordinator
Nicholas B.A. Nicholson, Guest Curator
Cathy Crane, Corcoran Coordinating Curator

**DESIGN:**
Signal Communications, Silver Spring, MD

**PHOTOGRAPHY:**
Alexander Igorevich Savelyev, for all objects from The State Archives of the Russian Federation,
Pavlovsk State Museum-Preserve and Tsarskoye Selo State Museum-Preserve
Carmel Wilson-Fromson, for all objects from the State Diamond Fund of the Russian Federation and
Yaroslavl State Architectural and Historical Museum-Preserve

**COLOR SEPARATIONS:**
Photo Effects, Bethesda, MD

**TRANSLATORS:**
Dr. Georgi Tolsiyakoff, Dr. Nadia Strenk, and Elena Siyanko

**PRINTING:**
Alan Abrams Associates in association with Peake Printers, Inc.,Washington, DC

ACKNOWLEDGMENTS

*The organization of this exhibition has been supported by:*
       The Ministry of Foreign Affairs of the Russian Federation
       The Ministry of Culture of the Russian Federation
       Embassy of the Russian Federation in the United States
       Gokhran of the Russian Federation
       The State Archives of the Russian Federation
       ITAR-TASS
       International Cultural Center of the Ministry of Culture
        of the Russian Federation

*The development of this exhibition in the United States has been sponsored by:*
       Lazare Kaplan International Inc.
       The Starr Foundation
       Conoco, Inc.
       Fish and Richardson, PC
       Dow, Lohnes & Albertson, PLLC
       O'Connor & Hannan, L.L.P.

# CONTENTS

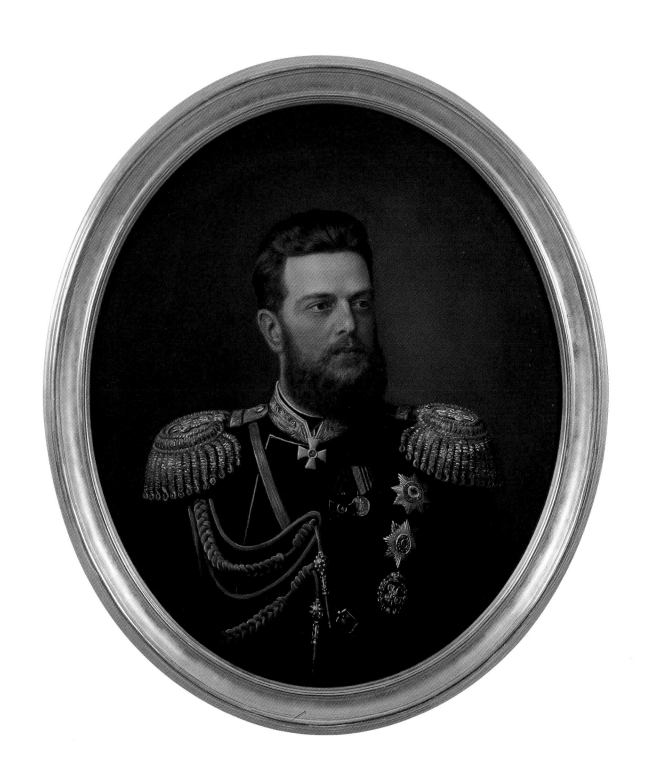

J ewels of the Romanovs: Treasures of the Russian Imperial Court was conceived to commemorate the 125th anniversary of the first State visit of a member of the Russian Imperial family to the United States. The occasion of the visit of the Grand Duke Alexei Alexandrovich, fourth son of Emperor Alexander II, has been marked by sending a selection of objects that illustrate the exceptional quality of the fine and decorative arts in pre-revolutionary Russia. The exhibition features archival materials from the State Archives of the Russian Federation relating to the voyage of the Grand Duke Alexei, ecclesiastical objects from the Yarsoslavl State Architectural and Historical Museum-Preserve, eighteenth and nineteenth century paintings, costumes, and decorative arts from the Tsarskoye Selo and Pavlovsk State Museum-Preserves, and perhaps most spectacularly, an unprecedented selection of jewels from the State Diamond Fund of the Russian Federation. This exhibition explores the development of the skills of Russian silversmiths, goldsmiths, and jewelers from the eighteenth to the twentieth centuries, and illuminates the long history of friendship between Russia and America.

On the verge of the millennium, the exhibition's Russian and American organizers hope it will help carry that spirit of friendship and goodwill from the past on into the future.

## RUSSIA AND AMERICA: EARLY CONCORD

In 1775 and again in 1776 King George III of England sent a request to the Empress Catherine II "the Great" that he be allowed to retain the services of Cossacks as mercenaries in his struggle to subdue the colonial rebellions in America. Catherine politely declined, thus removing a potential obstacle to America's independence. A welcome corollary to that independence was autonomy in matters of trade. From the dawn of the nineteenth century fortunes were to be made from raw materials which could not be shipped to Europe: cotton, indigo, tobacco, sugar, and lumber–considered one of Russia's most important imports. The famous hardwood parquet floors of the Russian palaces owe a significant debt to American trade as Cuban mahogany and Brazilian rosewood made their way to St. Petersburg via New York and Philadelphia.

Russia and America's diplomatic relationship began with the appointment of Levett Harris as American Consul at St. Petersburg in 1803. His early letters to Congress detail the arrival of shipments of sugar and hardwoods. American-Russian relations were further

*(Opposite page)*
**RUSSIAN SCHOOL**
GRAND DUKE ALEXEI ALEXANDROVICH, CIRCA 1870
*Oil on canvas*
*35 x 29 5/8 in (89 x 75 cm)*
*Tsarskoye Selo State Museum-Preserve*
*Inv. No. ED-480-X*

9

**ADDRESS OF THE CITIZENS
OF THE UNITED STATES OF
AMERICA TO EMPEROR
ALEXANDER II**
1866
*Ink, parchment*
*State Archives of the Russian Federation*
*Inv. No. GA RF, f. 678, op. 1, d. 31*

Presented as an expression of
gratitude to the Imperial govern-
ment and people of Russia for
their support during the
American Civil War, and for the
warm reception which was
extended to the American delega-
tion during its visit to Russia.

improved as the French, under Napoleon, began to try to control European trade. Russians
offered to serve as protectors for American ships in Europe, and they secured significant
advantages by so doing. Harris wrote:

> *"How long this country will be able to preserve this transit trade is a question I shall not pretend to
> answer; tho' I consider it almost impossible for Russia to retain for another year the conclusive bene-
> fit of transmitting colonial supplies to nearly the whole continent; such would as ill comport with
> the policy and views of France as it is obviously opposed to her interests and those of the states she
> has subjected to her dominion."* [1]

In his letters, Harris reveals this concern over Russia's abilities to preserve American
trade as Napoleon's influence spread. In 1811, Russia and the United States each faced sig-
nificant threats; the Russians anticipated the imminent arrival of Napoleon, who had
recently broken the Peace of Tilsit, and the Americans were faced with the return of British
troops to the former colonies. Alexander I had this advice for the American Consul regard-
ing their conflict:

> *" 'To make something clear to the English, you must show them your teeth. Continue the war,' said
> he, 'if you must, and do it with vigor!' "* [2]

After the Russian and American victories in 1812-14, the two nations resumed extensive
trade and diplomatic relationships.

## THE AMERICAN CIVIL WAR AND RUSSIAN INTERVENTION

As the century continued, Russian-American friendship grew. Widespread American
sympathy for the Russian cause in the Crimean War of 1854-55 produced new trade
opportunities for the United States in the Far East. Then, in 1861, Emperor Alexander II
with a stroke of his pen, liberated 30 million Russian serfs. In 1863, President Lincoln issued
his world-changing Emancipation Proclamation. Despite the Czar's expressed hopes for rec-
onciliation between the American states, the U.S. Civil War had erupted, and began to
threaten the economic interests of certain European powers. The British and French, fear-

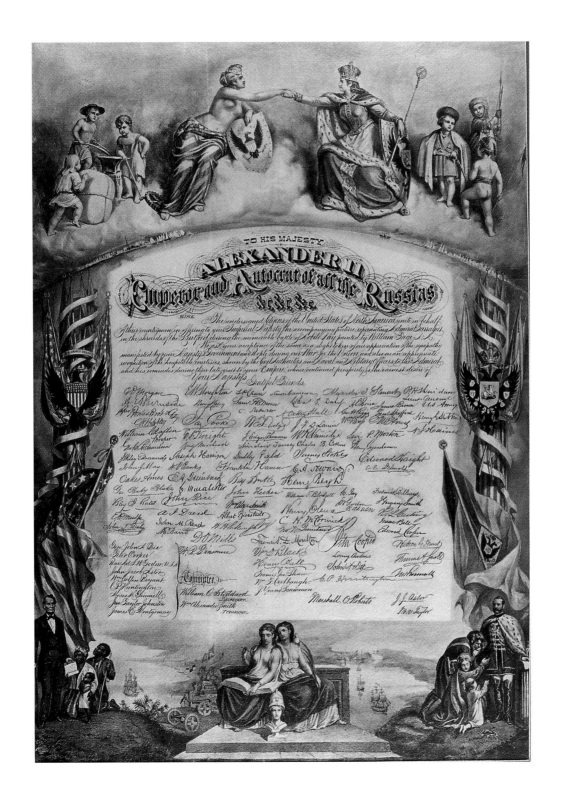

11

ing the loss of their important cotton shipments, sent fleets to discourage a northern blockade of southern ports. Russia countered by sending into American waters naval forces of their own which were welcomed into the harbors of New York and San Francisco.

After the conclusion of the war in 1865, and with the boom of reconstruction of the Union underway, President Grant invited the Russian Imperial family to make a State visit to the United States to thank them appropriately for their efforts on behalf of the Union.

Alexander II sent his twenty-one-year-old son, the Grand Duke Alexei Alexandrovich as his representative because of the latter's active role in the Russian Navy. Alexei had been made a naval officer at birth, was an Ensign at seven, and by ten had participated in naval maneuvers. At twenty-one, he was the perfect choice for the voyage. On his return from his American trip in 1873, he became Captain First Class, and in 1883 he was to become General-Admiral of the Imperial Fleet, a post he was to hold until 1905.

## THE GOODWILL MISSION OF THE GRAND DUKE ALEXEI: 1871-1872

The Grand Duke Alexei arrived in the United States, and cabled his father, the Emperor regularly. On arriving in Washington, DC, Alexei telegraphed St. Petersburg:

*"The Courier has arrived, and I was presented to the President. Tomorrow we return to New York."* [3]

The Emperor responded with a telegram to his wife, the Empress Maria Alexandrovna, who was vacationing at the Palace of Livadia in the Crimean:

*"...yesterday the Grand Duke Alexei met with the President of the United States. Everything went well."* [4]

The letters which Alexei wrote to his mother are far more detailed and candid, giving a revealing and informative look at the Grand Duke's impressions of America and American society:

*"American society has made a very strong impression on me. The men, in general, are intelligent and energetic, but completely lack even the simplest of manners, with the exception of naval sailors. The women, on the contrary, are extremely well brought up, and we have a false impression of them in*

*Europe. Their intellectual development is not less than that of our women, but concerning religion, they have very liberal conceptions though they go often to church. I was shocked by the number of beauties, particularly in New York and St. Louis. Concerning my success among American women, of which the newspapers have written so much, I can honestly say that this is complete nonsense. They look at me as people look at a caged crocodile or a monkey of unusual size, but then, having looked me over, become completely indifferent."* [5]

Grand Duke Alexei was especially pleased to visit the American South, which proved interesting to him, as well as familiar:

*"We are going to Louisville, one of the most implacable enemies of the Northern States during the war, and I must say that their invitation surprises me, since we were always for the North, in other words, against the Southern States, and yet, in spite of this, they invite us anyway. In Louisville, there was a wonderful reception, speeches, and a ball, as usual. I must say, that there is a wonderful difference between Americans of the North and the South. Here, they are much more like Europeans, their manners are completely different. It is apparent that they are old feudal landowners, and in general, are similar to Our own old nobility."* [6]

It can be said that no State visitor to America ever enjoyed such varied and unusual experiences as those of the Grand Duke. In Boston, he was treated to a magnificent display of rhetoric and poetry from Harvard's President Eliot to Messrs. Longfellow, Whittier, and Oliver Wendell Holmes. In Nebraska, he hunted buffalo with Custer, Sheridan, and Buffalo Bill Cody. Over 1,300 people took part in this extraordinary event, organized by the commander of the Western Military territory, Colonel Sheridan, at the invitation of Chief Spotted Tail. Alexei responded to his father the Czar:

*"Warm thanks to You and Mother for heartfelt congratulations; returned from the hunt with an escort of Indians! Killed three Bison. Departing for Denver."* [7]

The Grand Duke Alexei's remarkable journey ended in New Orleans, a city he greatly enjoyed for its cosmopolitan air and European feeling.

**SOUVENIR ALBUM OF THE EMPRESS MARIA ALEXANDROVNA, WIFE OF ALEXANDER II**
CIRCA 1850
*White velvet, gold, rubies, diamonds, sapphires, gems*
*State Archives of the Russian Federation*
*Inv. No. GA RF*

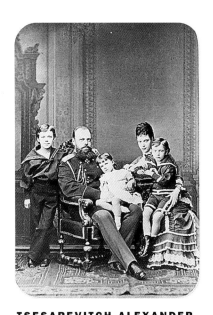

*"New Orleans produces a completely European impression, since the whole populace and society speaks French. An enormous crowd gathered here for the Mardi Gras, but I must say that I thought this carnival would be more lively. An enormous procession of people on horseback, on foot, and in carriages wearing masks passed through the whole town with music and shouts, but nevertheless, a sort of artificiality reigns in all this merrymaking, as if someone had ordered them to dress up like monsters, and pretend that they were having fun. There is a very good French opera here, and many other theaters. We stayed in New Orleans six days, and that is our last stay in America."* [8]

As his visit to New Orleans inaugurated the "Rex" theme which has marked the occasion down to this day, along with the song he so much admired, "If Ever I Cease to Love," (as well as the singer, the celebrated Lydia Thompson) it can safely be said that Alexei infused a new and lasting spirit into the venerable Mardi Gras.

Grand Duke Alexei's visit was a milestone in American-Russian relations; not only was it the first time a member of a European Imperial or Royal family had been officially received by the American government, it was the first major acknowledgment of the power and position of the United States by a European nation. Alexei retained fond memories of his time in the United States, though in a letter to his sister-in-law, the future Empress Maria Feodorovna, he did confess:

*"In America there were too many [balls]! There have been around fifty, and the women there dance their whole lives, beginning at the age of three, and ending at the age of eighty. I must confess that I have never seen so many beauties in Europe."* [9]

Relations between the Russia and the United States continued to flourish until their mutual engagement in the First World War, the "Great War" which established the United States as the political equal of any European power, but also swept the Romanov dynasty from the throne it had occupied for over three hundred years. Russian and American soldiers, together with their allies, were subsequently called upon to contain Fascism, concluding their share of that arduous struggle with a handshake at the River Elbe. Despite the continued changes in Russia, both political and social, the material culture of Imperial Russia has been saved and preserved by the heroic efforts of its curators, archivists, and historians.

This resplendent collection of Imperial treasures, costumes, portraits, and archival materials, evokes the grandeur of Russian history. Its religious objects, unrivaled in beauty and workmanship, convey the power of the Russian soul–of a faith, transcending time and circumstance, that has sustained a great people for a thousand years. Taken together, from an American perspective, this exhibition calls to mind two centuries of interwoven destinies; of a friendship forged in common causes, and made more than strong enough to endure occasional differences, by the natural affinity of our two peoples. May this warm glow from a shared past help light our paralleled journey into the future.

The State Archive of the Russian Federation was founded in 1921 and has at its disposal more than five million unique files on the history of Russia. Of special interest are the personal papers and possessions of the Russian emperors and of Romanov family members.

The papers and other objects from these archives presented in this exhibition are "Documented Treasures" of Russia.

[1] Letter from Levett Harris, 10/22 December 1811, to James Monroe. General Records of the Department of State, Record Group 59, Dispatches from US Consuls in St. Petersburg, Russia, 1803-1906, M81, June 13, 1810-August 16, 1830. Archives II; College Park, MD.

[2] Letter from Levett Harris, 4/16 September 1812, to James Monroe, *ibid*.

[3] Telegram from the Grand Duke Alexei to his father, Emperor Alexander II from Washington, DC, 23/12 November, 1871, State Archives of the Russian Federation, Moscow. GA RF f. 678, op. 1, d. 739, l. 188.

[4] Telegram of the Emperor Alexander II to the Empress Maria Alexandrovna at Livadia, 12 November 1871, State Archives of the Russian Federation, Moscow. GA RF f. 641, op. 1, d. 23, l. 29.

[5] Letter of the Grand Duke Alexei to his mother, the Empress Maria Alexandrovna in St. Petersburg, 12 September 1871, State Archives of the Russian Federation, Moscow. GA RF f. 728, op. 1, d. 3246.

[6] *ibid*

[7] Telegram of the Grand Duke Alexei Alexandrovitch to his parents, St. Petersburg 17/5 January 1872, State Archives of the Russian Federation, Moscow. GA RF f. 678, op.1, d. 739, l. 208.

[8] Letter from the Grand Duke Alexei Alexandrovitch to his mother, the Empress Maria Alexandrovna, St. Petersburg, 25 January 1872. State Archives of the Russian Federation, Moscow. GA RF f. 728, op. 1, d. 3246.

[9] Letter of the Grand Duke Alexei to his sister-in-law, the future Empress Maria Feodorovna, 25 January 1872, State Archives of the Russian Federation, Moscow. GA RF f. 1831, op. 1, d. 26.

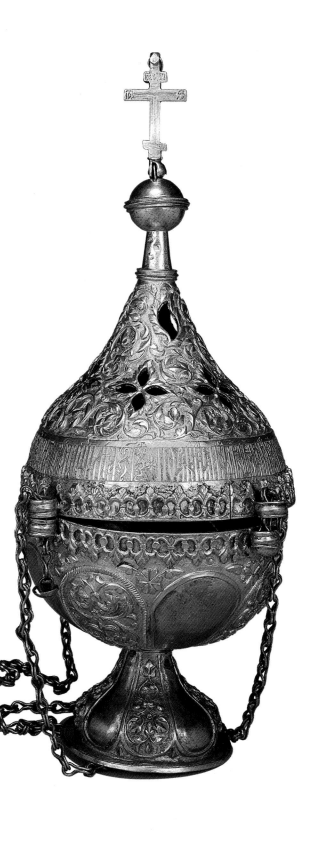

**THURIBLE (CENSER)**
MOSCOW, 1652
*Parcel-engraved and gilt silver*
*29 1/2 x 6 7/8 in diam*
*(75.0 x 17.4 cm diam)*
*Gift of Tsar Alexei Mikhailovitch (reigned*
*1645-1676) to the Cathedral of the*
*Assumption, Yaroslavl*
*Yaroslavl State Architectural and Historical*
*Museum-Preserve*
*Inv. No. YMZ-6040, s/u 536, DM-263*

**ICON "OUR LADY OF KAZAN"**
17TH CENTURY
*Tempera on panel, pearls, diamonds*
*(.04 carats), rubies (6.4 carats), sapphires*
*(10.56 carats), garnets (6.6 grams), chryso-*
*prase (.20 grams), chrysolite (.20 grams),*
*glass, glass beads, gilt-metal, silk needlework*
*12 3/4 x 11 1/4 in (32.4 x 28.4 cm)*
*From the Church of Sts. Kozma and Demian,*
*Yaroslavl*
*Yaroslavl State Architectural and Historical*
*Museum-Preserve*
*Inv. No. YMZ-7895*

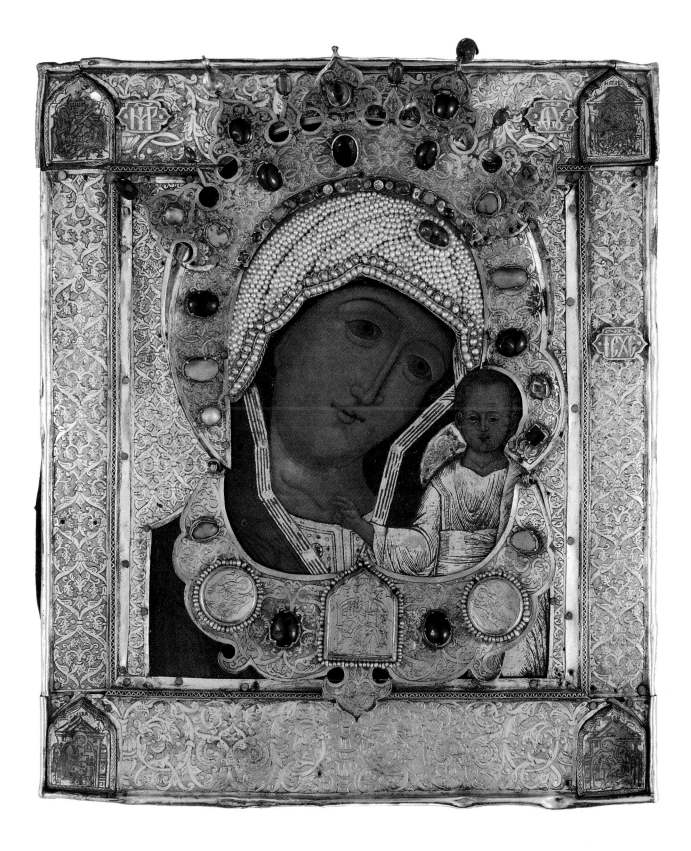

17

**COVERING VEIL "THE
BURIAL OF CHRIST"**
17TH CENTURY
*Satin, silk, velvet, pearls (290 gr), semi-
precious stones, gold thread, silk embroidery*
*26 1/2 x 33 3/8 in (67.2 x 84.7 cm)*
*Yaroslavl State Architectural and Historical
Museum-Preserve*
*Inv. No. YMZ-5468*

**CHALICE**
YAROSLAVL, 1671
*Parcel-gilt and engraved silver*
*11 5/8 x 8 in diam (29.4 x 20.2 cm)*
*From the Church of the Holy Apostle John,
Yaroslavl*
*Yaroslavl State Architectural and Historical
Museum-Preserve*
*Inv. No. YMZ-7237, s/u 147, DM-204*

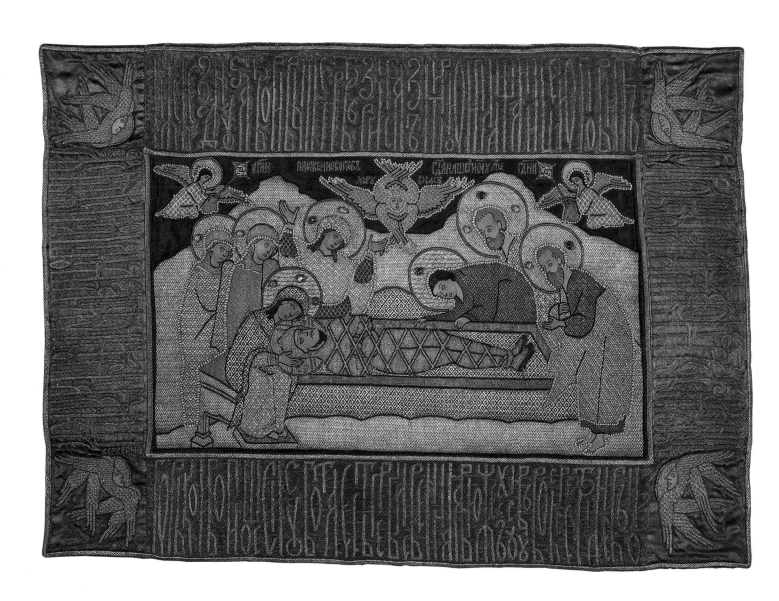

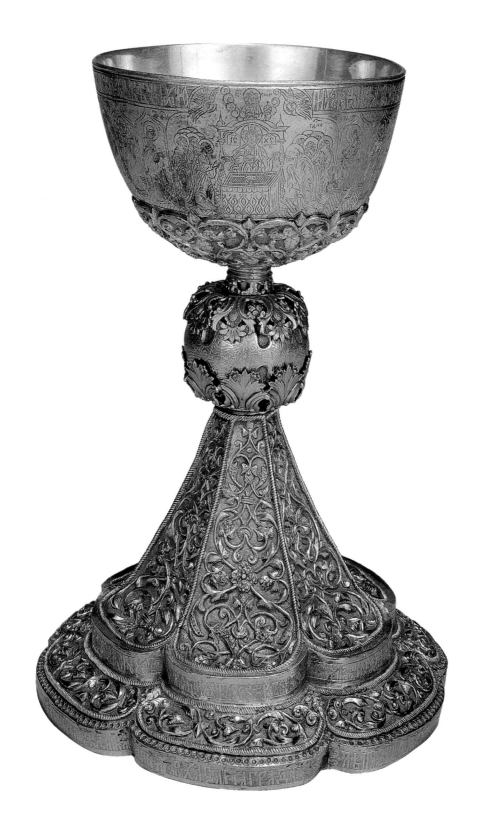

**PANAGIA (ECCLESIASTICAL PENDANT)**

RUSSIA, LATE 17TH–EARLY
18TH CENTURY

*Silver, gold, emeralds (17.96 carats), uncut
diamonds (3.64 carats), sapphire (71.76
carats), rubies (10.48 carats), garnets (.92
grams), enamel*
*8 1/8 x 3 1/4 in (20.6 x 8.2 cm)*
*From the Sacristy of the Monastery of the
Saviour, Yaroslavl*
*Yaroslavl State Architectural and Historical
Museum-Preserve*
*Inv. No. 7882, g/u 1, DM-163*

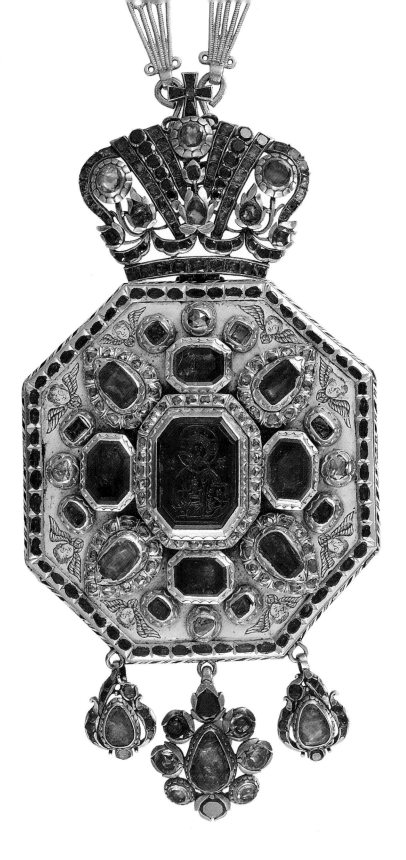

**PANAGIA (ECCLESIASTICAL PENDANT)**

RUSSIA, SECOND HALF OF THE 17TH CENTURY

*Silver, gold, enamel, sapphires (78.68 carats), rubies (14.40 carats), emeralds (10.90 carats)*

*4 7/8 x 3 1/8 in (12.4 x 7.7 cm)*

*From the Sacristy of the Monastery of the Saviour, Yaroslavl*

*Yaroslavl State Architectural and Historical Museum-Preserve*

*Inv. No. 7885, g/u 428, DM-166*

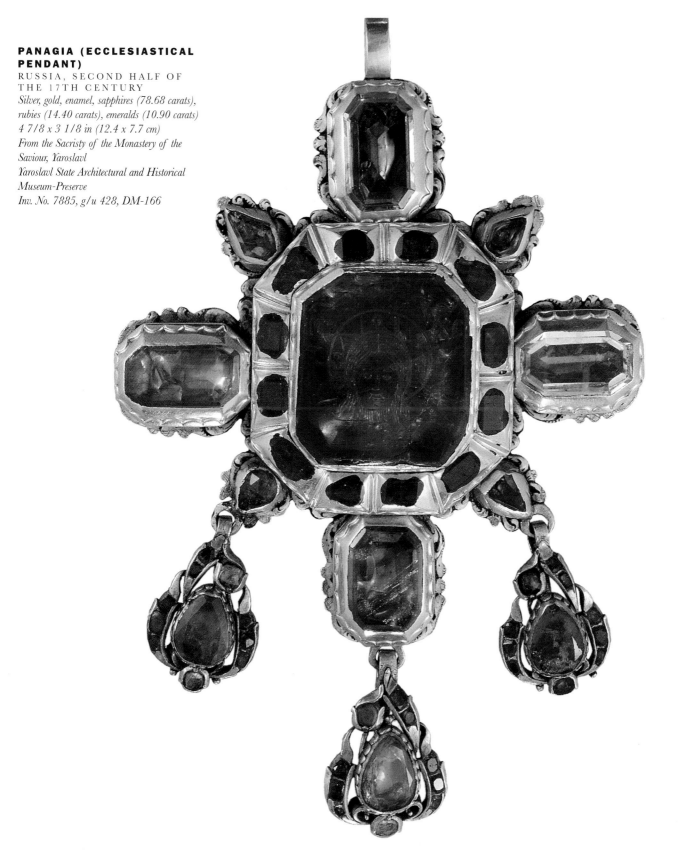

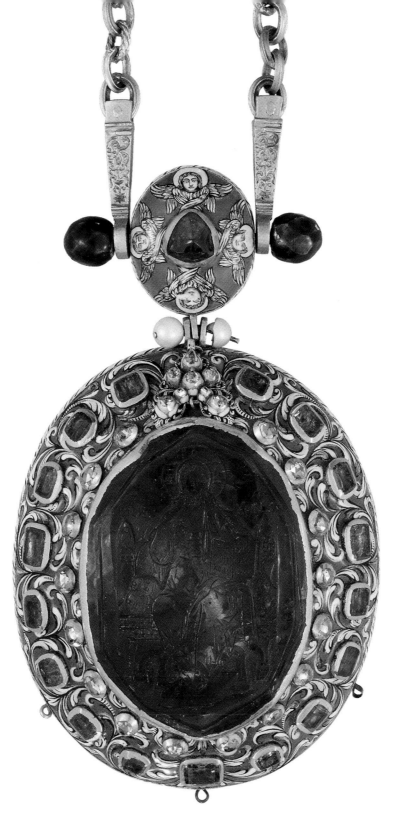

**PANAGIA (ECCLESIASTICAL PENDANT)**
RUSSIA, LATE 17TH CENTURY
*Silver, gold, emeralds (23.70 carats), uncut diamonds (3.88 carats), sapphire (4.50 carats), enamel (5.0 carats)*
*8 3/4 x 3 7/8 in (22.1 x 9.9 cm)*
*From the Sacristy of the Monastery of the Saviour, Yaroslavl*
*Yaroslavl State Architectural and Historical Museum-Preserve*
*Inv. No. YMZ-7881, g/u 427, DM-167*

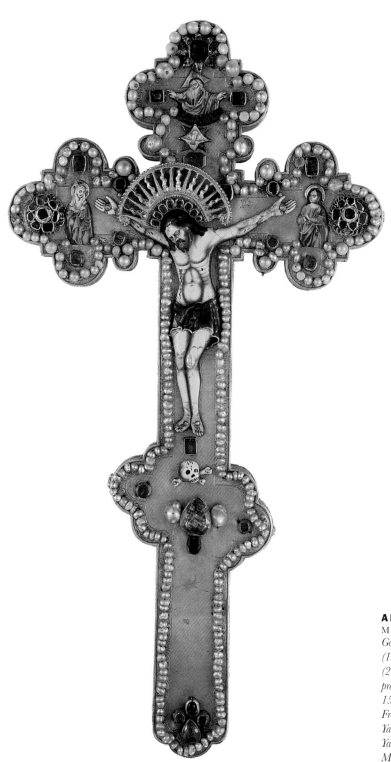

**ALTAR CROSS**

MOSCOW, 1731

*Gold, uncut diamonds (.48 carats), emeralds*
*(13.50 carats), rubies (17.75 carats), pearls*
*(240 carats), sapphire (24.85 carats), semi-*
*precious stones, enamel*
*15 3/4 x 8 1/4 in (40 x 21 cm)*
*From the Tolog Monastery of the Saviour,*
*Yaroslavl*
*Yaroslavl State Architectural and Historical*
*Museum-Preserve*
*Inv. No. YMZ-7880, s/u 4*

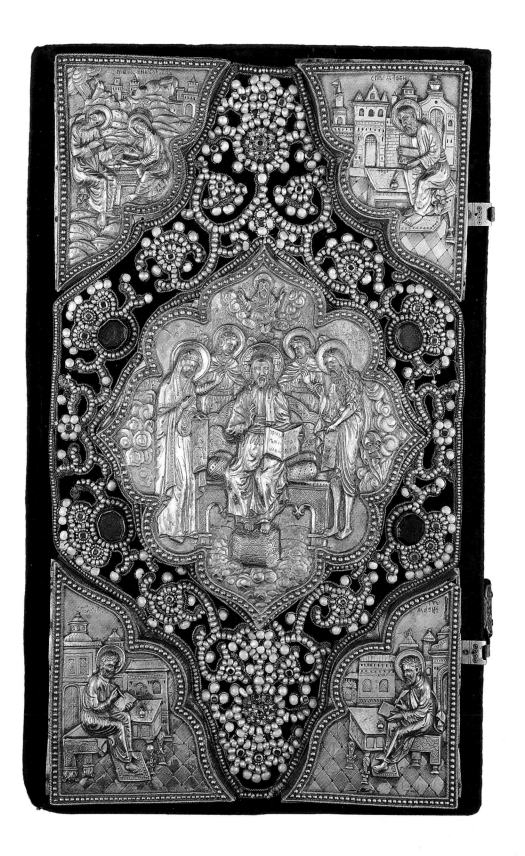

**ALTAR BOOK OF GOSPELS**
PRINTED MOSCOW 1703,
BINDING RUSSIAN, EARLY
18TH CENTURY
*Paper, silver, pearls, glass, velvet,*
*silk embroidery*
*18 1/4 x 12 in (46.3 x 30.5 cm)*
*Yaroslavl State Architectural and Historical*
*Museum-Preserve*
*Inv. No. YMZ-7383, s/u 112*

**CROWN FOR AN ICON**
**OF OUR LADY OF TOLOG**
19TH CENTURY
*Cut and uncut diamonds (.4 carats),*
*emeralds (7.3 carats), sapphire (6.0 carats),*
*rubies (.7 carats), topaz, coral, pearls, semi-*
*precious stones, glass, gilt thread, silver*
*14 1/4 x 14 7/8 in (36.2 x 37.7 cm)*
*From the Church of the Saviour and Christ's*
*Transfiguration, Yaroslavl*
*Yaroslavl State Architectural and Historical*
*Museum-Preserve*
*Inv. No. YMZ-7899*

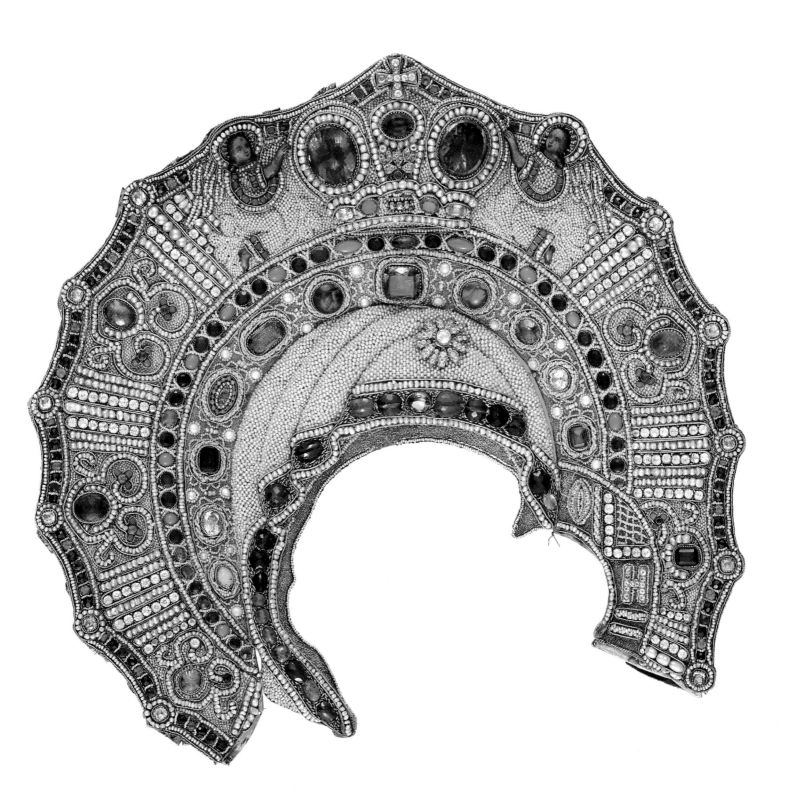

**SMALL BOUQUET**
RUSSIA, CIRCA 1760
*Gold, silver, diamonds (68.65 carats), enamel,*
*colored foil*
*5 7/8 x 2 3/8 in (15.0 x 6.0 cm)*
*The State Diamond Fund of the Russian Federation*
*Inv. No. AF-5*

This small bouquet of foiled white
diamonds, worn clipped at the waist,
was created for Empress Elizabeth I.

**PAIR OF EARRINGS IN THE**
**FORM OF BEES**
RUSSIA, CIRCA 1760
*Gold, silver, diamonds (48.61 carats), enamel,*
*colored foil*
*2 1/2 x 1 5/8 in (6.25 x 4.0 cm)*
*The State Diamond Fund of the Russian Federation*
*Inv. No. AF-7*

This pair of earrings and the
diadem *en suite* feature the technique of
foiling, in which colored foil is placed
beneath each stone imparting a soft
pastel color to the white diamonds.
These earrings and the diadem were
created for Empress Elizabeth I.

**DIADEM-BANDEAU IN THE FORM**
**OF A GARLAND**
RUSSIA, CIRCA 1760
*Gold, silver, diamonds (90.12 carats), enamel,*
*colored foil*
*10 1/4 x 1 5/8 in (26.0 x 4.2 cm)*
*The State Diamond Fund of the Russian Federation*
*Inv. No. AF-6*

This diadem features the technique of
mounting *en tremblant*. The bees are
attached to small springs which vibrate
as the wearer moves. This diadem,
and the earrings *en suite* were given to
the State by Empress Elizabeth I.

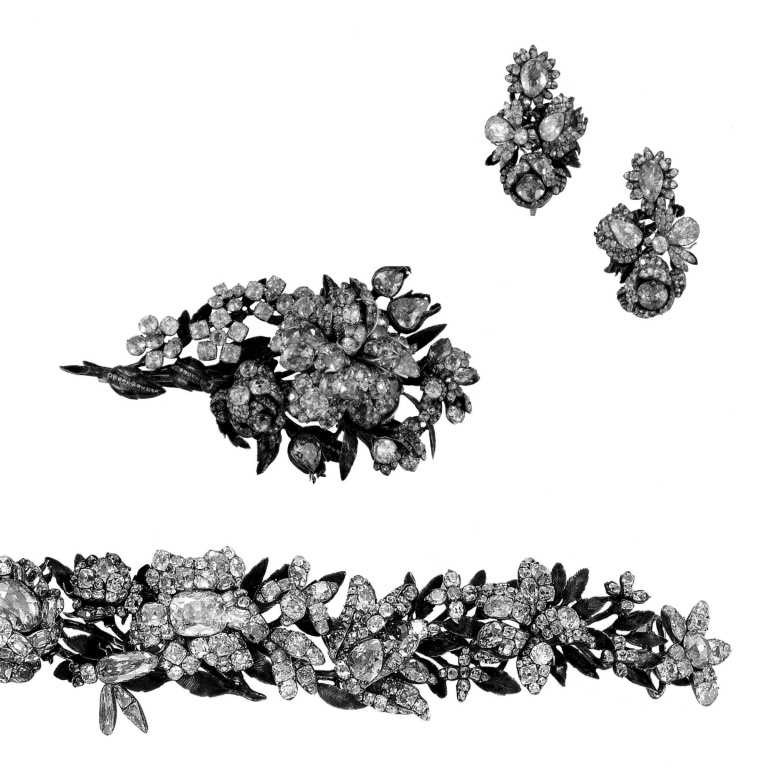

**PENDANT,
"CAESAR'S RUBY"**
MOUNTING MANUFACTURED IN
WESTERN EUROPE IN THE
17TH CENTURY
*Gold, pink tourmaline-rubelite
(52.00 carats), enamel
1 5/8 x 1 1/8 x 1 in (4.0 x 2.7 x 2.3 cm)
The State Diamond Fund of the Russian
Federation
Inv. No. AF-12*

This jewel was presented to
Catherine II "the Great" in 1777
by King Gustav of Sweden who
made a State visit to Russia in that
year. Thought to be a ruby of
ancient cut which had belonged to
Caesar. The academician A.E.
Fersman discovered the stone to be
a tourmaline-rubelite, probably of
Indian, rather than Classical origin.

## BROOCH IN THE FORM OF
## THE HORN OF PLENTY

LOUIS-DAVID DUVAL,
SIGNED DUVAL
ST. PETERSBURG, CIRCA 1774
*Gold, silver, diamonds (41.89 carats)*
*2 7/8 x 2 7/8 in (7.2 x 7.2 cm)*
*The State Diamond Fund of the*
*Russian Federation*
*Inv. No. AF-45*

This brooch was originally
conceived as an aigrette for
Catherine II "the Great," and its
purchase was recorded by Adam
Vasilievich Olsufiev: "To the jew-
eler Duval for an aigrette of dia-
mond brilliants, 2,250 roubles."
Born in Geneva, Duval at first
worked independently, but in May
of 1789 founded the Petersburg
Firm "Louis-David Duval and
Son." By September of 1800, the
firm had grown, and was known
as "Duval Brothers."

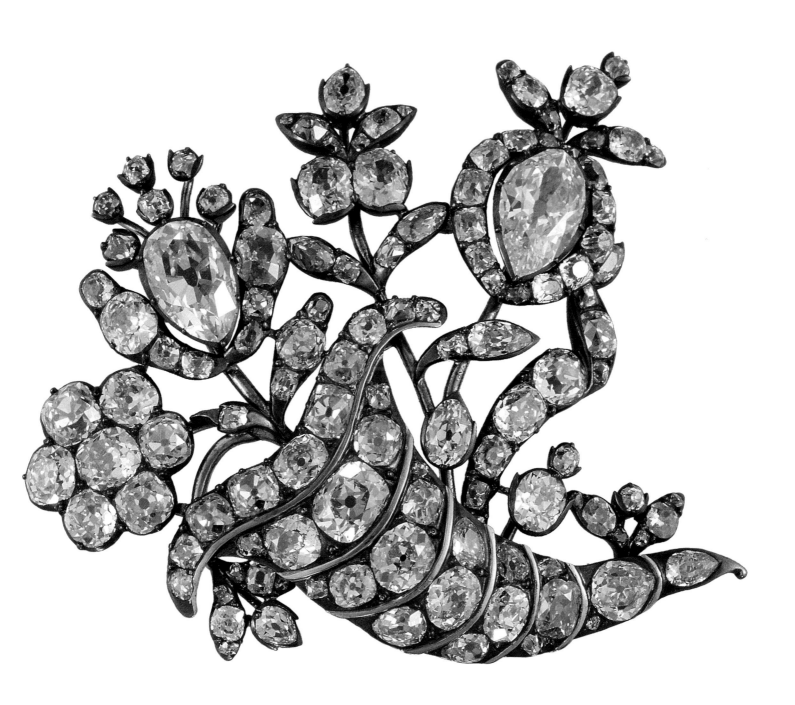

**STICKPIN**

RUSSIA, CIRCA 1800
*Gold, silver, blue diamond (7.6 carats),*
*white diamonds (.96 carats)*
*1 x 3/4 in (2.6 x 1.8 cm)*
*The State Diamond Fund of the Russian*
*Federation*
*Inv. No. AF-8*

This pin features a blue diamond
believed to have been cleft from
the famed stone called "Le
Tavernier"–the same stone as the
Hope diamond. The stone,
originally set as a ring for Empress
Maria Feodorovna, wife of
Emperor Paul I, was given to the
Diamond Fund in 1860, by her
daughter-in-law, the Empress
Alexandra Feodorovna.

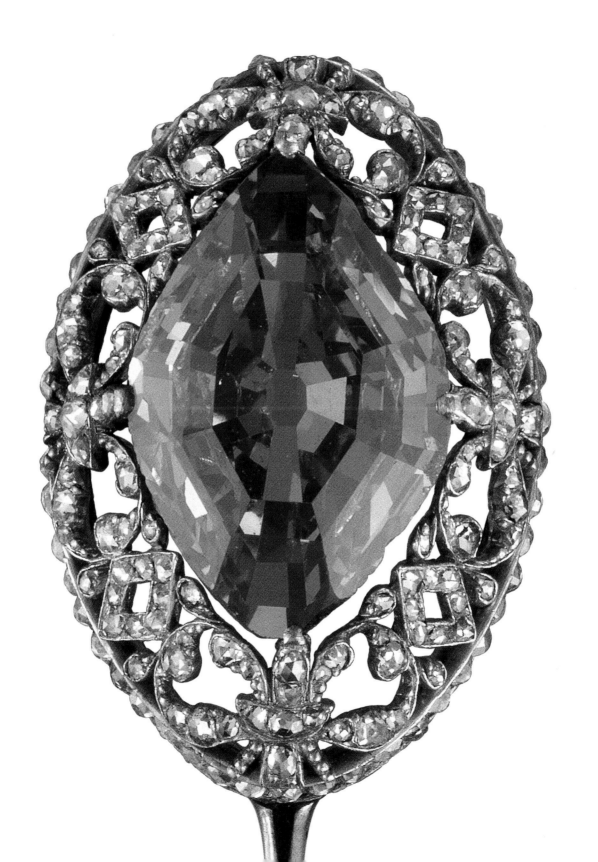

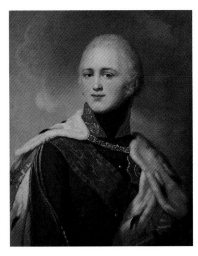

**VLADIMIR LUKITCH
BOROVIKOVSKII
(1757-1825)**
PORTRAIT OF EMPEROR
ALEXANDER I, CIRCA 1802
*Oil on canvas*
*74 x 60 cm*
*Pavlovsk State Museum-Preserve*
*Inv. No. TsKh-2028-III*

Alexander I "the Blessed," came
to the throne in 1801 after the
assassination of his father Paul I.
Alexander was to become one of
Russia's greatest heroes by defeat-
ing Napoleon in the war of 1812.
Alexander's extraordinary military
skill coupled with the severity of
the Russian winter made
Napoleon's defeat inevitable.
Heralded as a saviour by the
Russian people, and by Europe as
a military genius, Alexander I
died in 1825, and it is now
believed that the Emperor faked
his own death and went into holy
seclusion as a monk known as
Feodor Kuzmich.

**BRACELET**
RUSSIA, CIRCA 1820
*The miniature by Winberg after the portrait*
*by George Dawe*
*Gold, enamel, ivory, gouache, table-cut portrait*
*diamond (27 carats) x 7 3/4 in*
*1 3/8 x 7 7/8 in (3.5 x 19.6 cm)*
*The State Diamond Fund of the Russian*
*Federation*
*Inv. No. AF-68*

The diamond in this bracelet,
called the "Tafelstein" or table-
stone, entered the Imperial collec-
tions in 1771. It was purchased in
January from the banker
Friederichs for the sum of 11,500
roubles, and entered into the col-
lection as a "great flat brilliant."
The diamond figured in a number
of pieces over the years, but it was
after the death of Alexander I in
1825, that the current bracelet
was conceived as a "*sentiment*," or
memorial bracelet. The miniature,
by Winberg, depicts the portrait of
Alexander by the Englishman
George Dawe (now in the State
Russian Museum, St. Petersburg).
Instead of covering the portrait
with glass, however, this historic
stone was used to unusual effect.

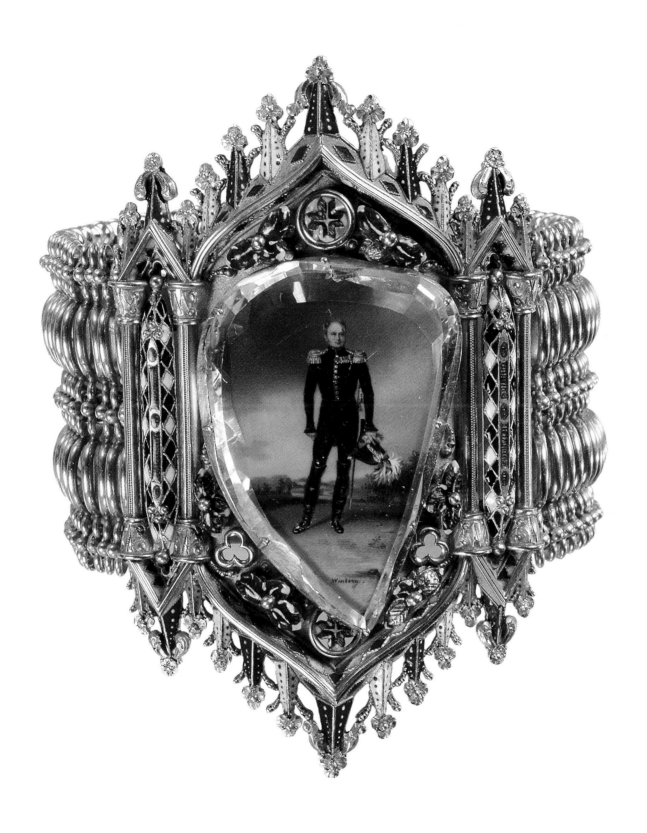

**NICHOLAS ANDREEVITCH
LAVROV (1820-1875)**
PORTRAIT OF EMPEROR
ALEXANDER II, 1860
*Signed and dated in Russian* N. Lavrov
*Oil on canvas*
*168 x 110 cm*
*Tsarkoye Selo Museum-Preserve*
*Inv. No. ED-639-X*

Alexander II was to reign as one of
the most enlightened Russian
Emperors. In striking contrast to
the militaristic and repressive reign
of his father, Nicholas I, Alexander
was responsible for many important
social reforms, the most resounding
being the liberation of the serfs in
1861. Alexander II was married to
Empress Maria Alexandrovna, a for-
mer Princess of Hesse-Darmstadt,
but had an ongoing and highly
important relationship with Princess
Catherine Dolgorukaya, a descen-
dant of Prince Yuri Dolgoruky,
prince of Kiev. Though Catherine
was beneath his rank, and could
not be proclaimed Empress,
Alexander II married her against
Dynastic law, and created for her
the title of Princess Yurievskaya.

**SAPPHIRE BROOCH**
RUSSIA, CIRCA 1860
*Gold, silver, diamonds (56.60 carats), Ceylon
sapphire (260.37 carats)*
*2 1/8 x 2 3/8 in (6.0 x 5.3 cm)*
*The State Diamond Fund of the
Russian Federation*
*Inv. No. AF-67*

Unique in the world for its combi-
nation of size, color, clarity, and
extraordinary cut, this sapphire
was purchased by Emperor
Alexander II at the London Great
Exhibition of 1862, where it was
advertised in the old carat weight
of 252.25/32 carats. Presented to
his wife, Empress Maria
Alexandrovna, it was presented to
the Diamond Fund in 1882.

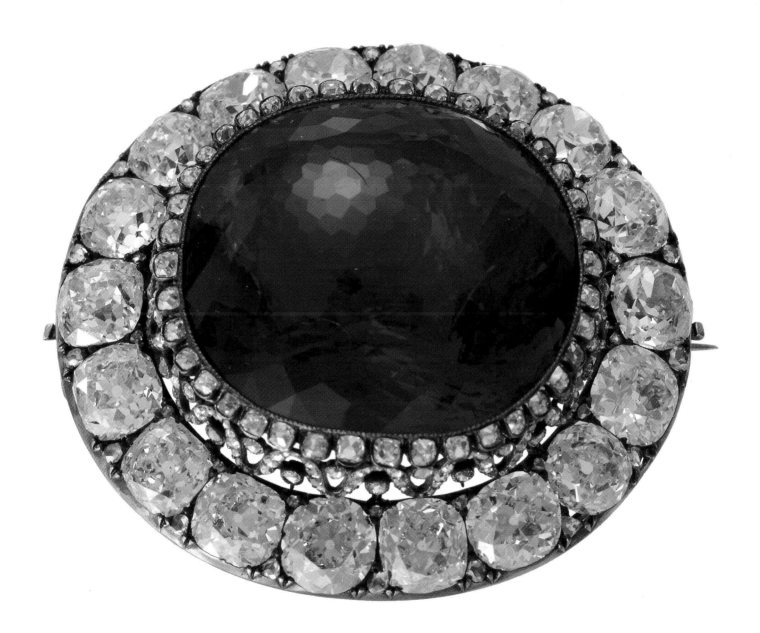

## STAR OF THE ORDER OF ST. ANDREW

ST. PETERSBURG, CIRCA 1775
*Gold, silver, diamonds (24.27 carats), enamel*
*3 1/4 x 3 1/4 in (8.0 x 8.0 cm)*
*The State Diamond Fund of the*
*Russian Federation*
*Inv. No. AF-36*

This, the most important order of the Russian Empire, was created in 1720 by Peter the Great, and was awarded to members of the Imperial family, and Russians who made extraordinary contributions to the Empire. This particular order was made for Emperor Paul I.

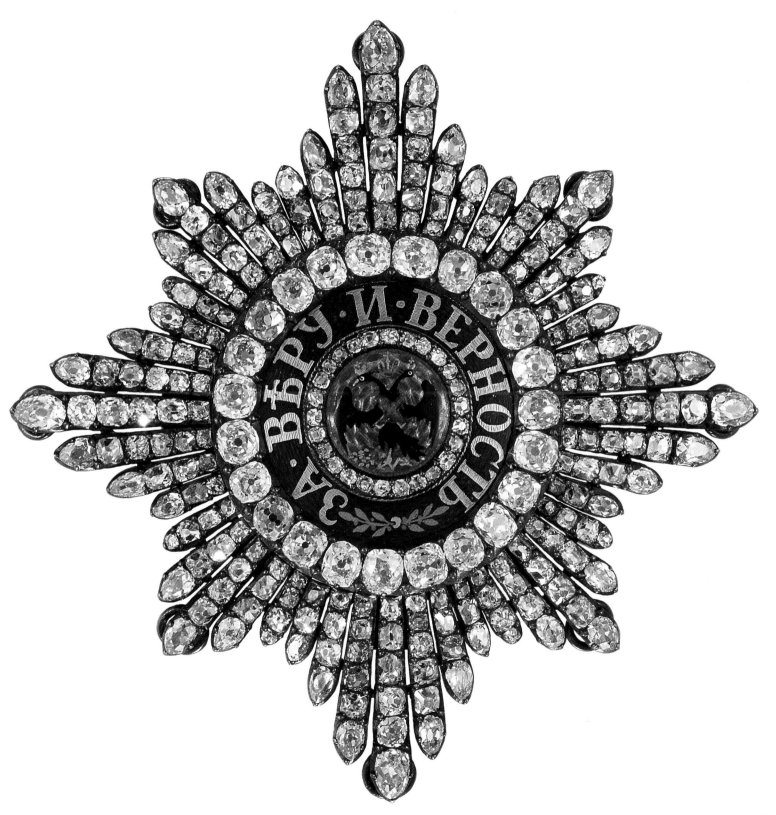

## NECK BADGE OF THE ORDER OF ST. ALEXANDER NEVSKY

LEOPOLD PFISTERER
MOSCOW, 1775
*Gold, silver, diamonds (97.78 carats), ruby glass, enamel*
*5 1/2 x 3 1/8 in (14.0 x 8.0 cm)*
*The State Diamond Fund of the Russian Federation*
*Inv No. AF-63*

After the Order of St. Andrew the First-Called, the most important Order of the Russian Empire was that of the Order of St. Alexander Nevsky. In 1240, Alexander Nevsky fought the Teutonic knights, and from its creation in 1725, was given to those who had distinguished themselves in battle. This particular neck badge came into the Diamond Fund from the collection of Emperor Paul I.

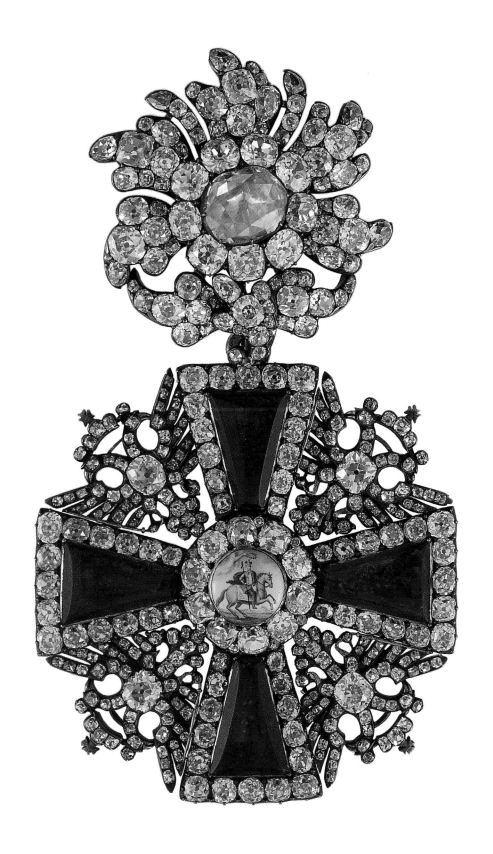

## NECK BADGE OF THE ORDER OF ST. ANNE

LOUIS-DAVID AND JACOB-DAVID DUVAL,
ST. PETERSBURG, CIRCA 1760
*Gold, silver, diamonds (9.11 carats), enamel, rubies (2.80 carats)*
*2 x 1 3/8 in (5.0 x 3.5 cm)*
*The State Diamond Fund of the Russian Federation*
*Inv. No. AF-37*

The Order of St. Anne was instituted in 1735 by Archduke Karl-Friedrich of Schleswig-Holstein-Gottorp in honor of his wife Anna, born a Russian Grand Duchess, and daughter of Peter the Great. When faced with lack of an heir, the Empress Elizabeth turned to her sister Anne's son, Peter of Holstein-Gottorp. Succeeding her as Emperor Peter III, Peter made the Order of St. Anne a Russian order, and awarded it to his son, the future Emperor Paul I, who acceded to the Dukedom of Schleswig-Holstein-Gottorp in 1773.

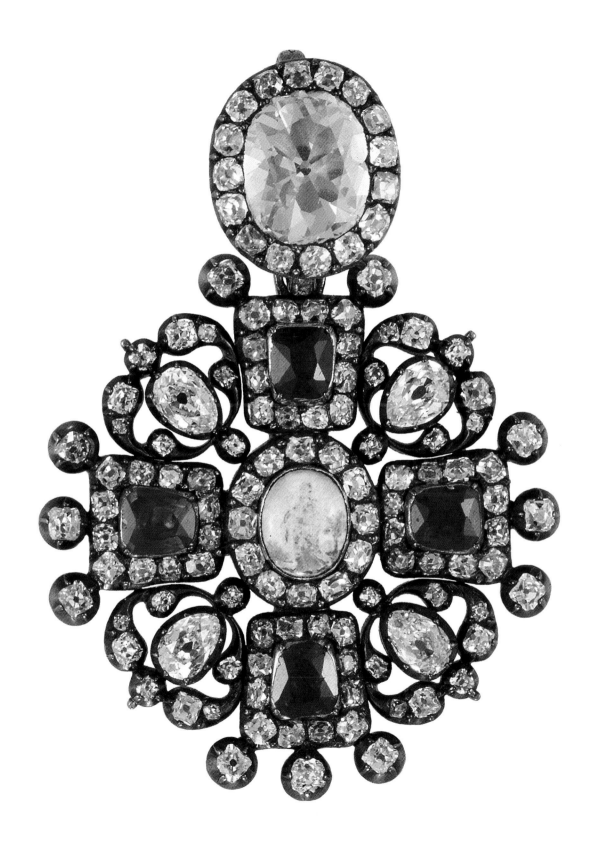

**BROOCH "ROSE"**
DESIGNED BY VIKTOR
NIKOLAEV, GENNADY
ALEKSAKHIN
MOSCOW, 1970
*Platinum, diamonds (47.23 carats)*
*5 7/8 x 4 in (15 x 10 cm)*
*The State Diamond Fund of the*
*Russian Federation*
*Inv. No. AF-155*

Before the sales of the 1920s and 1930s, a number of extraordinary flower studies existed in the collections as masterpieces of the jeweler's art. In an effort to prove that these skills had not been lost, a number of pieces based on the "lost" works were designed by the jewelers of the state treasury in 1970. This piece, a composite of several flower studies made in the nineteenth century, was conceived in platinum, and uses 1,466 invisibly set diamonds of exceptionally pure color and clarity, all of Russian origin.

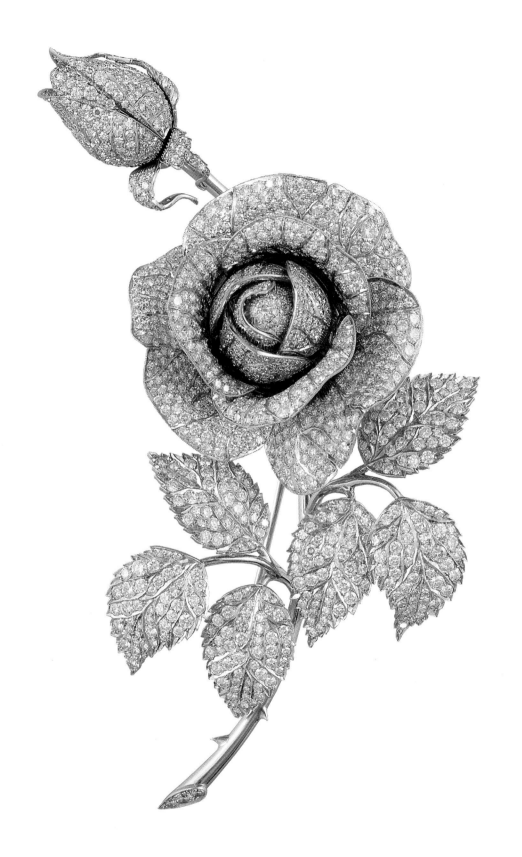

## DIADEM "RUSSIAN FIELD"

DESIGNED BY VIKTOR
NIKOLAEV, GENNADY
ALEKSAKHIN
MOSCOW, 1980
*Platinum, gold, white diamonds (129.62
carats), yellow diamond (35.25 carats)*
*4 3/8 x 13 3/8 in (11.0 x 34.0 cm)*
*The State Diamond Fund of the
Russian Federation*
*Inv. No. AF-170*

At the opening of the nineteenth century, Empress Maria Feodorovna, wife of Paul I, ordered a diadem from Duval Brothers, which was executed in the design of oak and laurel leaves, bordered by sheaves of wheat. This diadem was referred by her as "*Mon diadème en epis*" (my diadem of sheaves [of wheat]). In 1829, the Empress left the diadem to the Diamond Fund. Sold in 1929, the original is now lost, but seeking to recreate this stunning piece, designer Viktor Nikolaev and jeweler Gennady Aleksakhin faithfully recreated the piece from photographs and archival information, this time substituting platinum for silver, and using only stones of Russian origin. The piece centers an extraordinary yellow diamond of 35.25 carats.

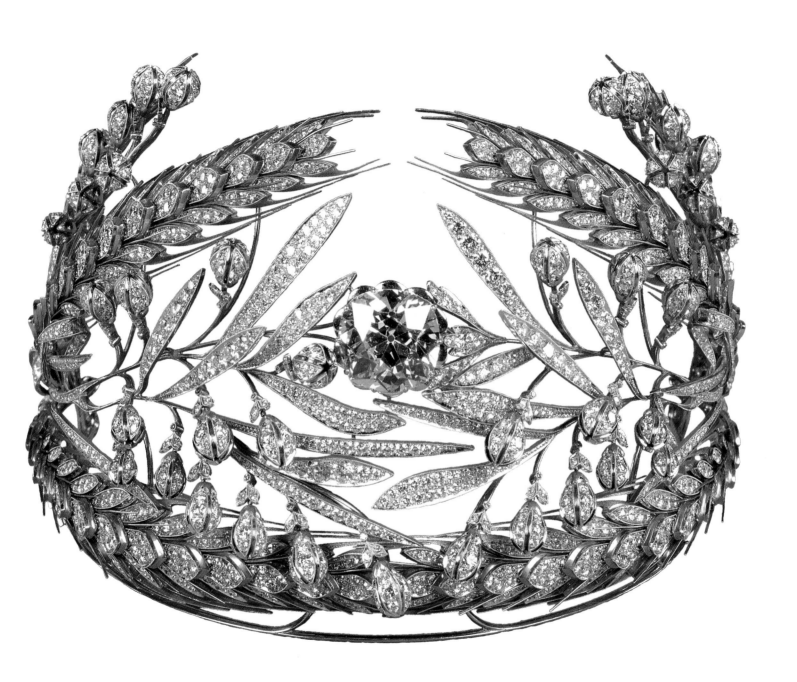

**JEWELRY CASKET**

CIRCA 1790

*Silver filigree, gold, pearls, rubies, beryl, quartz*
*4 3/8 x 13 3/8 in (11.0 x 34.0 cm)*
*Pavlovsk State Museum-Preserve*
*Inv. No. TsKh-905-VII*

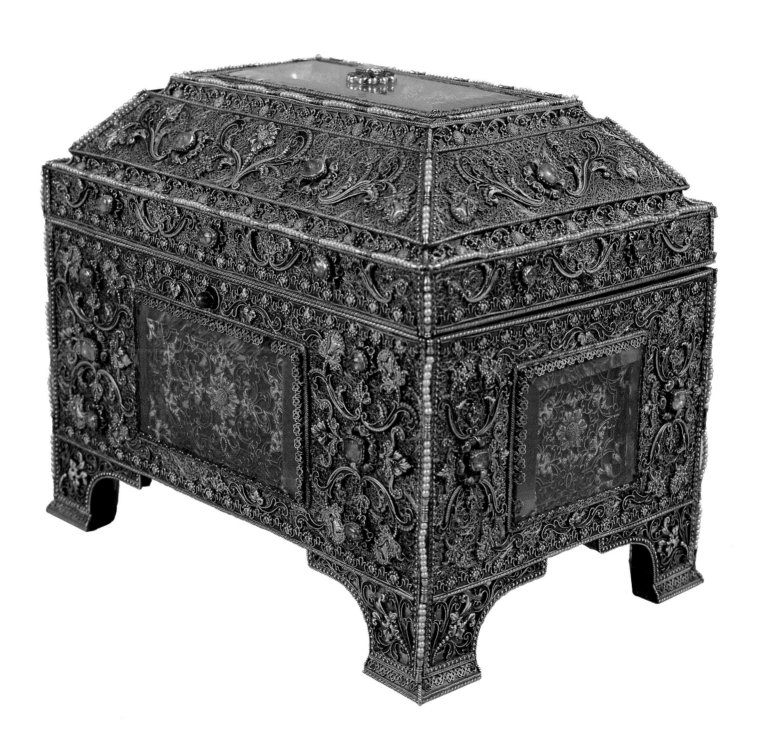

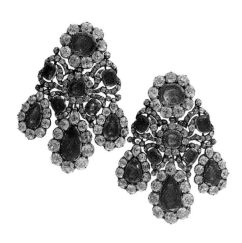

**RUSSIAN SCHOOL
COPY AFTER ALEXANDER
ROSLIN**
PORTRAIT OF EMPRESS
CATHERINE II,
CIRCA 1796
*Oil on Canvas*
*107 1/2 x 74 3/8 in (273.0 x 189.0 cm)*
*Tsarskoye Selo State Museum-Preserve*
*Inv. No. ED-796-X*

Born Princess Sophia of Anhalt-Zerbst, Catherine married Grand Duke Peter, nephew of the Empress Elizabeth, and moved to the court of Russia to find herself caught in intrigue. Ultimately, with the help of her guards' regiments, and her friend Princess Dashkova, Catherine engineered the assassination of her husband and the coup d'etat which placed her on the throne.

**PAIR OF EARRINGS**
LEOPOLD PFISTERER
ST. PETERSBURG 1764
*Signed and dated Pfisterer*
*Gold, silver, diamonds (41.08 carats), spinels*
*(46.90 carats)*
*Each 2 5/8 x 2 in (6.7 x 5.0 cm)*
*The State Diamond Fund of the Russian*
*Federation*
*Inv. No. AF-28*

In 1763, Prince Dmitri Mikhailovitch Golitsyn, the Russian Ambassador at Vienna, was instructed to engage a Court Jeweler for Catherine II. Pfisterer created and signed these earrings, which were part of a larger suite which included hair bows, brooches, and shoe buckles. The Empress signed Pfisterer to a six-year contract, and he remained in St. Petersburg for 34 more years.

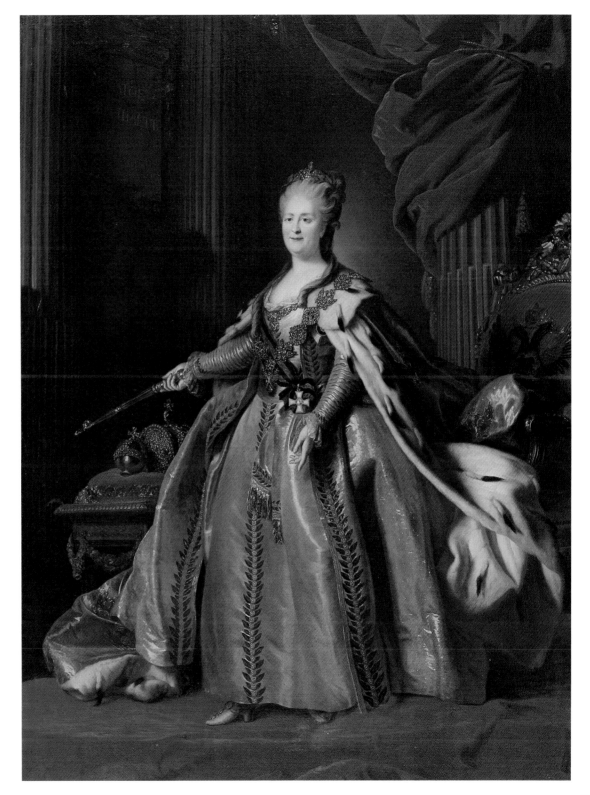

**ALEXANDER ROSLIN**
PORTRAIT OF GRAND
DUCHESS (LATER EMPRESS)
MARIA FEODOROVNA,
CIRCA 1770
*Oil on canvas*
*96 x 65 1/8 in (245 x 167 cm)*
*Pavlovsk State Museum-Preserve*
*Inv. No. TsKh-3749-III*

Mother of two Emperors,
Alexander I and Nicholas I, Maria
Feodorovna was born Princess
Sophia Dorothea of Wurttemberg,
and took the name Maria
Feodorovna upon her conversion
to Orthodoxy. Maria Feodorovna
proved to be one of the most
interesting women of her age; she
was instrumental in the construc-
tion of Pavlovsk Palace, which
stands today as one of the most
important examples of Russian
Neoclassicism.

**TWO SMALL ORNAMENTS
(BROOCH AND HAIR
ORNAMENT) IN THE FORM
OF BOWS**
LEOPOLD PFISTERER
MOSCOW, 1767
*Gold, silver, diamonds, rubies*
*Each 1 5/8 x 2 in (4.0 x 4.9 cm)*
*The State Diamond Fund of the Russian
Federation*
*Inv. No. AF-41*

These pieces were made by
Pfisterer on his arrival in Russia to
fill out the suite which originally
had secured him his position at
court. Originally two hair orna-
ments, one was remounted as a
brooch in the nineteenth century.

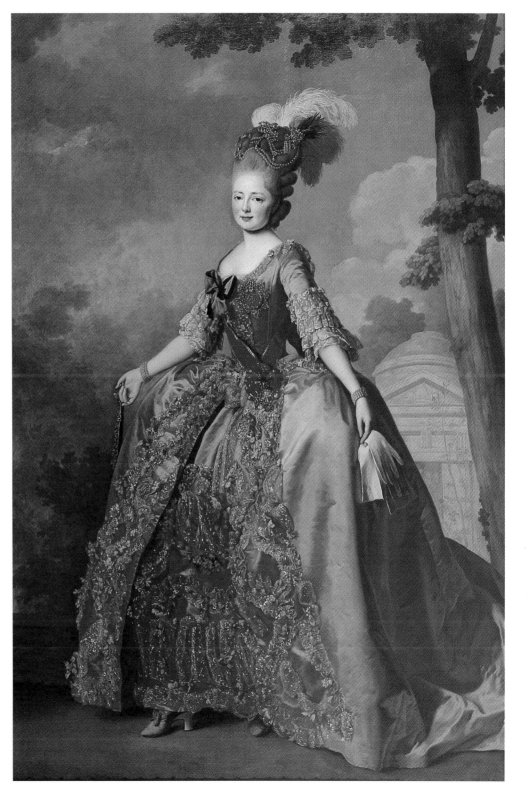

**TIMOLEON KARL VON NEFF**
**(1805-1876)**
PORTRAIT OF EMPRESS
ALEXANDRA FEODOROVNA,
CIRCA 1825
*Oil on canvas*
*56 1/8 x 42 in (143 x 106 cm)*
*Pavlovsk State Museum-Preserve*
*Inv. No. TsKh-3538-III*

This portrait depicts Alexandra Feodorovna in her robes as Empress of all the Russias. The Empress is seated on the ivory throne of Sophia Paleologue, brought from Byzantium in the fifteenth century (now in the collection of the Kremlin Armory Museum, Moscow). She also wears the small crown of the Empress, created by the jeweler Duval in the eighteenth century.

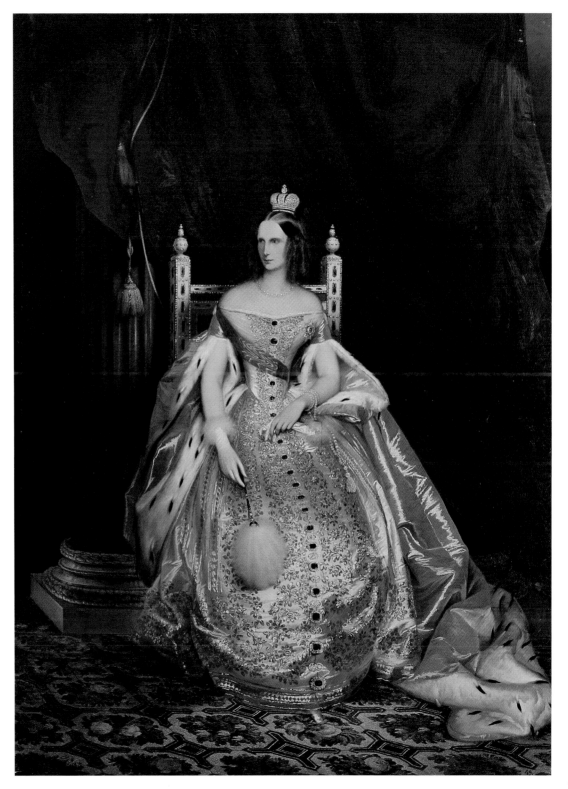

**PLASTRON**
DESIGNED BY V.V. NIKOLAEV
MOSCOW, 1985
*Platinum, gold, diamonds (58.27 carats),*
*emeralds (72.33 carats)*
*7 1/2 x 6 3/4 in (19.0 x 17.0 cm)*
*The State Diamond Fund of the Russian Federation*
*Inv. No. AF-185*

At the end of the nineteenth century, there was a revival of eighteenth-century jewelry forms, the "Plastron" or dress ornament among them. In 1896-1897, Empress Alexandra Feodorovna and her sister, Grand Duchess Elizabeth Feodorovna ordered emerald suites of jewelry from Bolin, an important St. Petersburg jeweler, and the Empress ordered a diadem and matching necklace with "cabochon emeralds... of three cubic centimeters." Later, the Empress ordered a plastron from Fabergé. This piece, one of her favorites, was sold. Nikolaev designed a piece which was not an exact copy, because the emerald-cut stones of the Fabergé workshop were substituted with cabochons, to unite the piece more closely to the Bolin suite.

**VITALY ZHURAVLEV (B. 1933) AFTER THE ORIGINAL BY NIKOLAI BODARIEVSKY (1850-1921)**
PORTRAIT OF EMPRESS ALEXANDRA FEODOROVNA, CIRCA 1900
*Oil on canvas*
*Tsarskoye Selo State Museum-Preserve*
*Inv. No. NV*

Born Princess Alix of Hesse-Darmstadt, Empress Alexandra Feodorovna was a favorite granddaughter of Queen Victoria of Great Britain. Alix met the Russian Tsarevitch Nicholas when she was only nine years old, and the two seemed to form an attachment to each other almost immediately. Married in 1895, the couple were passionately in love, and almost entirely concerned with their four daughters, and son and heir Alexei. This portrait, a copy of the 1900 original, shows the Empress at the height of her beauty and popularity. She is wearing the Bolin suite of emeralds and diamonds ordered after the coronation for which the Fabergé plastron was ordered (see the twentieth century case of jewels). The Empress was assassinated with her husband and children in 1918.

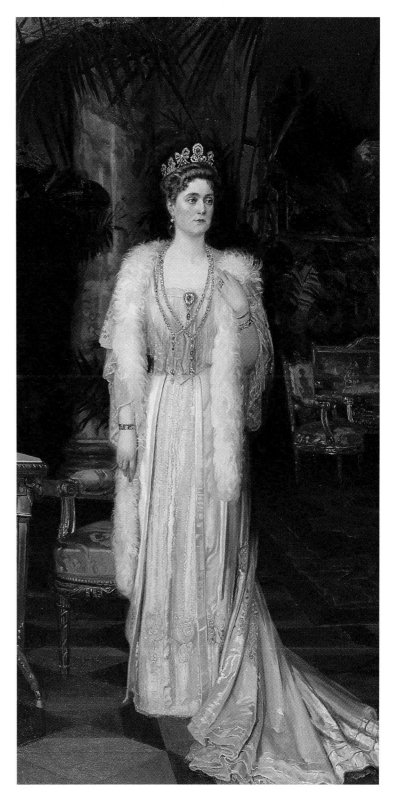

## ERNST KARLOVITCH LIPGART (1847-1932)

PORTRAIT OF NICHOLAS II
(1894-1917), 1900
*Signed and dated* Lipgart
*Oil on canvas*
*65 1/4 x 43 1/2 in (165.6 x 110.5 cm)*
*Tsarskoye Selo State Museum-Preserve*
*Inv. No. ED-555-X*

This portrait of Russia's last Tsar shows him in the White Hall of the Winter Palace, St. Petersburg. Nicholas stands as a controversial political figure. Reigning during a period of Russian history which was one of its most culturally important, Nicholas was also in power during Russia's most critical political periods. Although known as a religious, tranquil and family-loving man, failure in the Russo-Japanese war heightened his unpopularity, and in 1905, a revolution deprived him of absolute power. Further civil unrest brought about the February and October revolutions which resulted in his abdication in 1917, and his assassination in 1918.

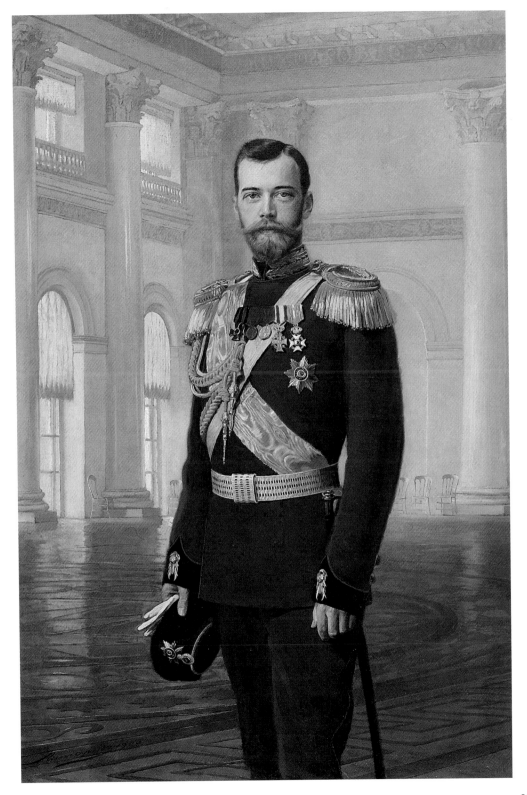

**FULL DRESS UNIFORM OF
EMPEROR PAUL I**
ST. PETERSBURG,
CIRCA 1790
*Wool, velvet, buckskin, canvas, silk, leather,
feathers*
*Pavlovsk State Museum-Preserve*
*Inv. Nos. TsKh-1636-II, TsKh-1638-II,
TsKh-1644-II, TsKh-1646-II, TsKh-1481-II*

Military uniform for men was of
paramount importance at the
Imperial Court and in civilian life.
If one was a member of the mili-
tary, or indeed held any official
Court or governmental position, a
uniform was involved. Everyone
from the Emperor of Russia down
to postmen, street cleaners, and
schoolchildren wore strictly codi-
fied forms of dress.

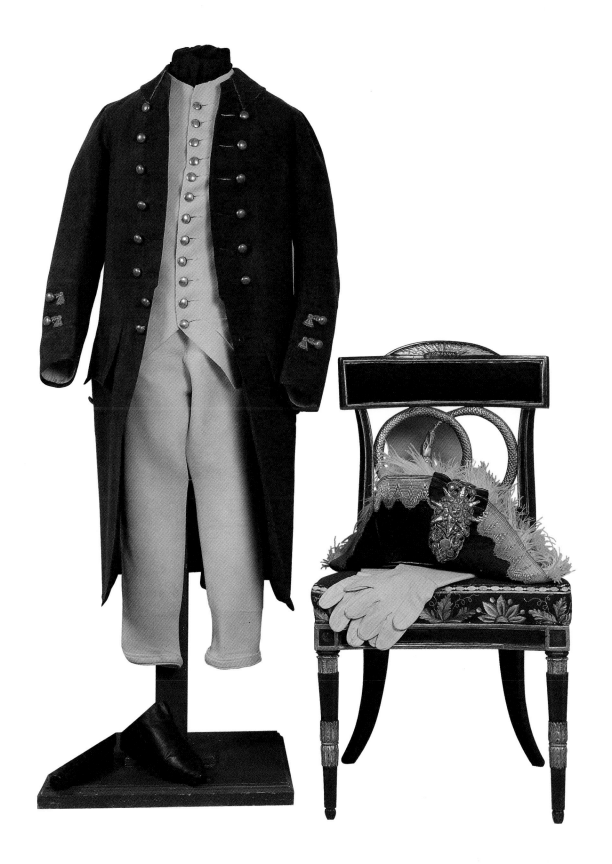

1817
*Wool, gold thread, sable fur*
*Tsarskoye Selo State Museum-Preserve*
*Inv. No. Jacket 44; doloman 89*

CIRCA 1840
*Wool, gold thread, sable fur*
*Tsarskoye Selo State Museum-Preserve*
*Inv. No. ED-933-II*

Members of the Imperial family
were often made honorary
patrons of foreign regiments.

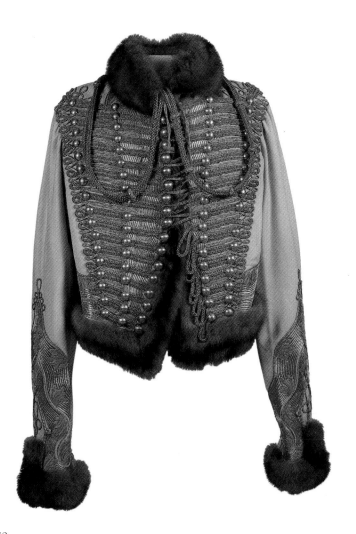

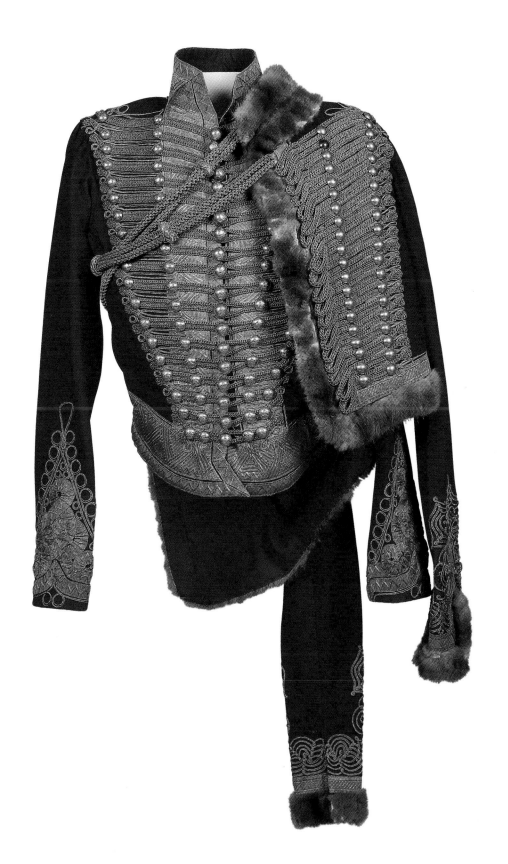

## BALLGOWN OF EMPRESS MARIA FEODOROVNA, WIFE OF PAUL I

RUSSIA, CIRCA 1827
*Silk, silk lace*
*Pavlovsk State Museum-Preserve*
*Inv. Nos. TsKh-2769-II, TsKh-2770-II*

This ballgown was made in 1827 for the Empress Maria Feodorovna to wear to a ball at the Belvedere Palace in Warsaw, Poland. The style of the gown, with its balloon sleeves and high Empire waist was known as a "Blondie."

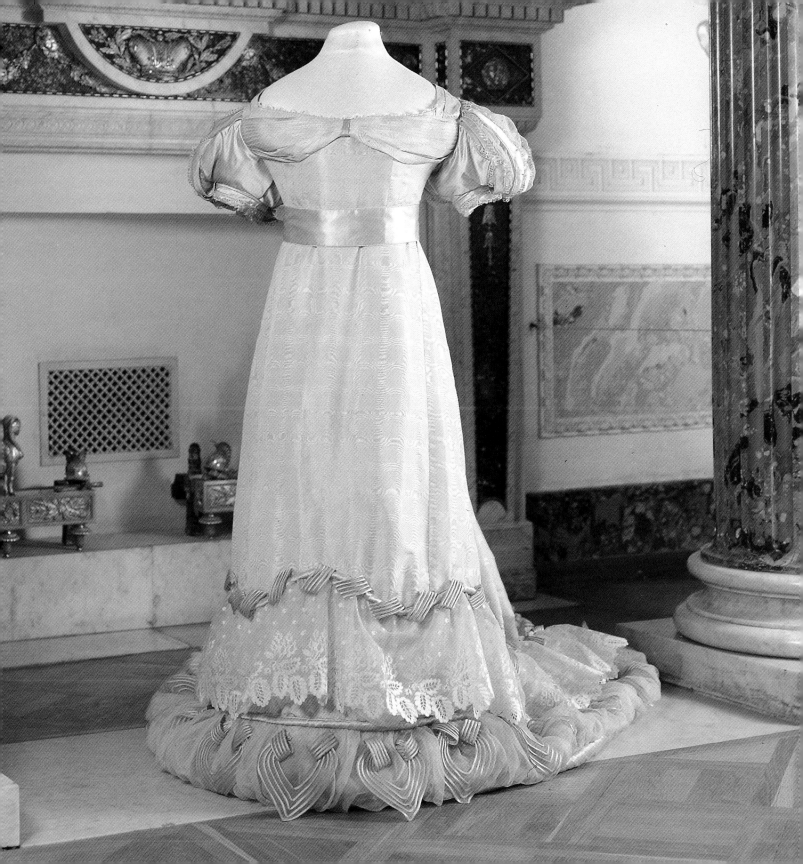

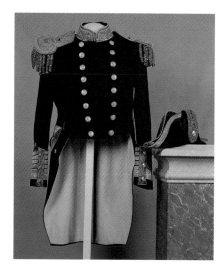

**UNIFORM OF AN ADMIRAL
OF THE BRITISH NAVY OF
NICHOLAS II**
ENGLAND, CIRCA 1890
*Wool, gold thread*
*Tsarskoye Selo Museum-Preserve*
*Inv. Nos. ED-1061-II, 1062-II,*
*and 1022-II*

**NAVAL OFFICER'S SWORD**
SHAF & SONS
ST. PETERSBURG
PERIOD OF ALEXANDER III,
CIRCA 1855
*Bulot alloy, gilt bronze, rubies, diamonds, sap-*
*phires, leather, silver thread*
*Tsarskoye Selo State Museum-Preserve*
*Inv. No. ED-406-II*

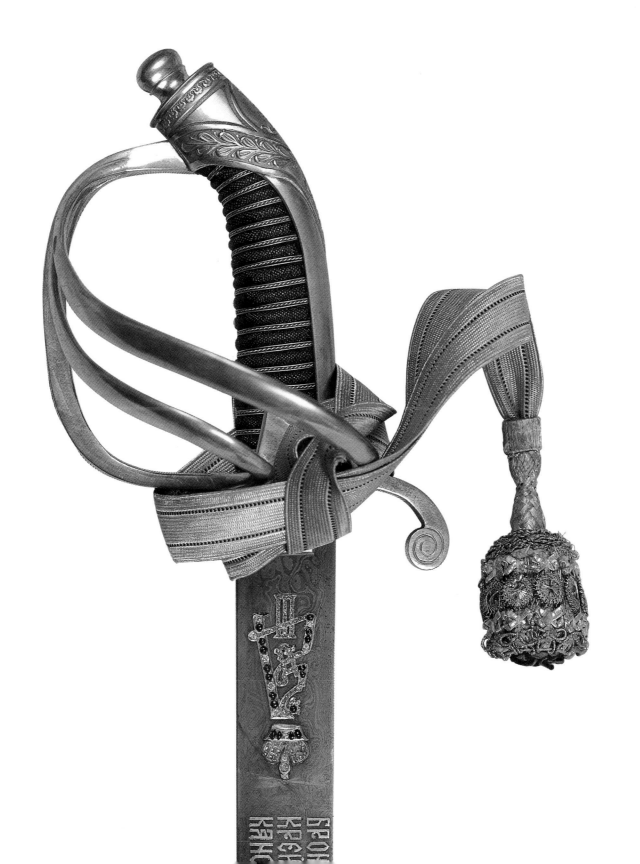

**COURT GOWN OF GRAND
DUCHESS XENIA
ALEXANDROVNA, SISTER OF
NICHOLAS II**
BY COURT COUTURIÈRE MME.
OLGA NIKOLAIEVNA
BULBENKOVA (1835-1918),
ST. PETERSBURG, 1894
*Blue velvet, white silk, gold thread*
*Jacket 28 3/4 in (73.0 cm), skirt 57 7/8 in*
*(147.0 cm), train 157 1/2 in (400 cm)*
*Tsarskoye Selo State Museum-Preserve*
*Inv. Nos. ED-1804-II, TsKh-2730,*
*TsKh-2732*

**COURT GOWN OF EMPRESS
ALEXANDRA FEODOROVNA,
WIFE OF NICHOLAS II**
RUSSIA, CIRCA 1890
*Pink silk moiré, silver thread*
*Pavlovsk State Museum-Preserve*
*Inv. Nos. TsKh-2724-II, TsKh-2725-II,*
*TsKh-2726-II*

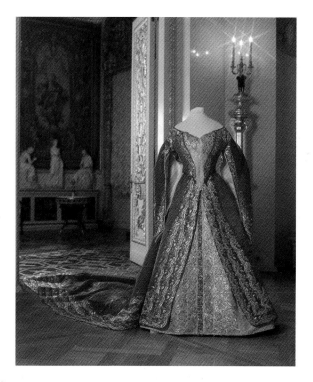

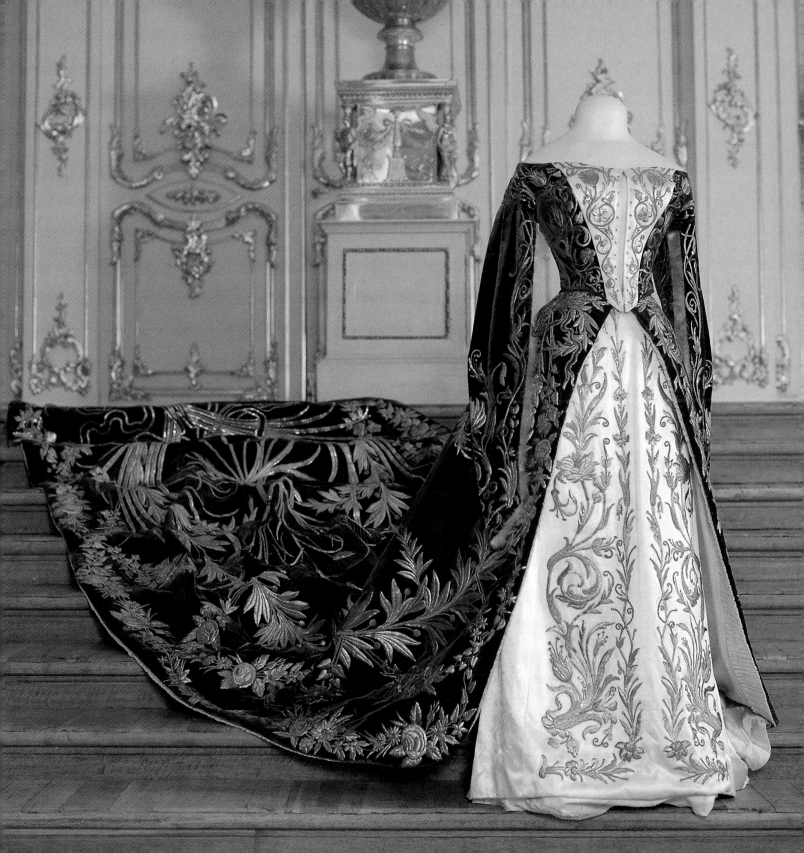

**COURT GOWN OF EMPRESS
ALEXANDRA FEODOROVNA,
WIFE OF NICHOLAS II**
BY COURT COUTURIÈRE
MME. OLGA NIKOLAIEVNA
BULBENKOVA (1835-1918),
ST. PETERSBURG,
CIRCA 1890
*White silk moiré, silver and gold thread*
*Pavlovsk State Museum-Preserve*
*Inv. Nos. TsKh-2728-II, TsKh-2727-II,*
*TsKh-2729-II*

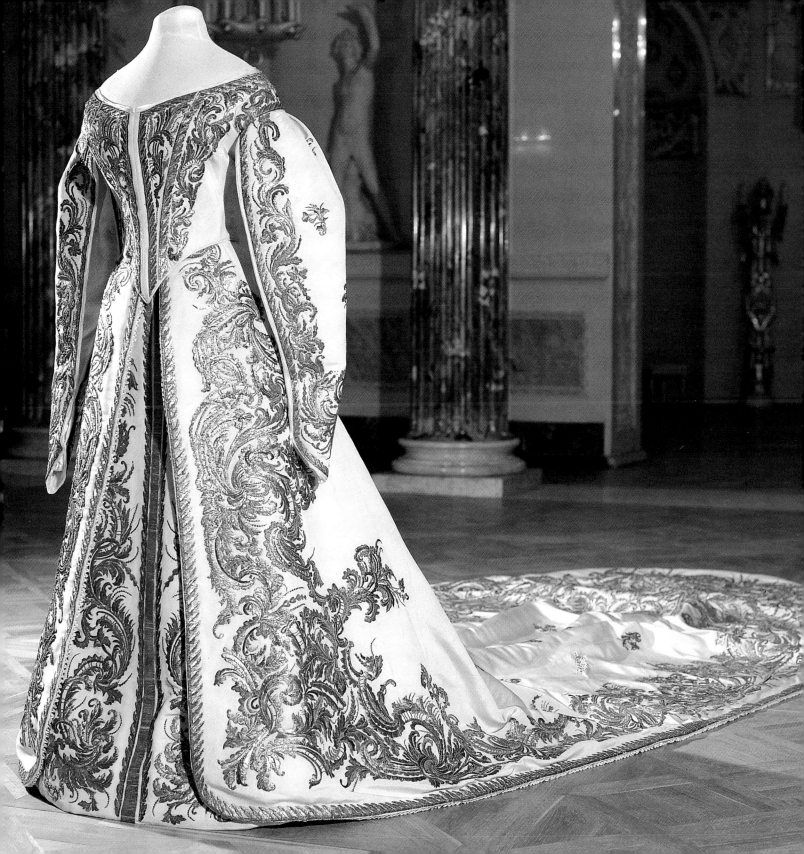

# A PARTIAL LINE OF DESCENT OF THE HOUSE OF ROMANOV

*Mikhail Feodorovitch Romanov (1613-1645)*

*Alexei Mikhailovitch (1645-1676)*

*Peter I "the Great" (1682-1725)  m.  Catherine I (1725-1727)*

*Elizabeth I (1741-1761)*

*Peter III (1761-1762)  m.  Catherine II "the Great" (1762-1796)*
*(Née Princess Sophie of Anhalt-Zerbst)*

*Paul I (1796-1801)  m.  Maria Feodorovna*
*(Née Princess Sophie of Württemberg)*

*Alexander I (1801-1825)  m.  Elizabeth Alexeievna*
*(Née Princess of Baden)*

*Nicholas I (1825-1855)  m.  Alexandra Feodorovna*
*(Née Princess of Prussia)*

*Alexander II (1855-1881)  m.  Maria Alexandrovna*
*(Née Princess of Hesse-Darmstadt)*

*Alexander III (1881-1894)  m.  Maria Feodorovna*
*(NéePrincess of Denmark)*

*Nicholas II (1894-1917)  m.  Alexandra Feodorovna*
*(Née Princess of Alix of Hesse)*